Curating the Complex & The Open Strike

Terry Smith

Curating the Complex & The Open Strike

Thoughts on Curating, volume 1
Edited by Steven Henry Madoff

Foreword
Steven Henry Madoff

Place is the nexus of motion, sensation, and meaning—an aggregation of mechanisms of mobility, individual acts of cognition, and shared decisions about what we'll tolerate, negotiate, and agree on regarding what being human means, privately and publicly. Place is this navigated locus, turning the fluidity of space into a site of meaning, a concentration of tasks in time that leads us to understandings of our humanity, its principles, violations, ambiguities, and decidable truths. I begin with this thought to situate curatorial work within the frame of our being together: *to situate*, from the Latin noun *situs*, identifies the original or fitting position of a thing, as of a part or organ, such that our situatedness, our site of concentrated meaning, is rooted in the fundamental well of each body's life.

The "curatorial," of course, is a sprawling generality, a surface inscribed with various scripts of activities whose intentions and apparatuses are diverse and shift with the necessities of every locality, every situs. In our technological time, the situated, the curatorial, and the exhibitionary are not limited by physical space, just as the objects of curatorial work and their intellectual scaffolding have long been extended into every genre, every discipline of knowledge, alive to patterns of being beyond our own. Yet whether physically located or not, the site of meaning, the curatorial site, wakes us to our different intensities of need and desire that demand continual reinterpretation—which means that they begin in a previous interpretation, a former understanding of precepts and valuations that wear away through material and ideological fatigue.[1]

So it is that sociality in curatorial sites, understood as meeting places to experience meaningfulness, approximates a Maxwell's demon, a motion machine that synchronizes the organs of our social being with the capturing of meaning as an energy that perpetuates itself. And to continue this conceit of motion, the curatorial in its largest sense is akin to Walter Benjamin's imagining of Paul Klee's *Angelus Novus*: the act of curating like the winged figure of history always looking rearward into the past, while being blown by time's winds toward the future.[2] Benjamin calls this progress. But if there's no golden ladder of meaningfulness scaled over time either in the production or consumption of curatorial ideas and the meanings they impart, there is always a relation between sociality, knowledge, and time gathered in the curatorial act, its inhabitation of meaninged place constantly reformulating. The sedimentation of art and curatorial histories; cultural histories; political conditions; typologies of class, gender, race, and religion compressed and deformed in the hydraulic vise of dominant powers... each of these in various weights of influence comprise what reformulation means in this context and, in fact, how each curatorial site of meaning will be turned and shaped at any given moment.

1 The subject of situated curatorial practices is a central focus of the essay by Zdenka Badovinac forthcoming in this series.
2 Walter Benjamin, "Theses on the Philosophy of History," in *Illuminations*, trans. Harry Zohn (New York: Schocken Books, 2007), 257–58.

The situatedness of the curatorial as an engine of time and in time may concentrate meaning, but it's also prismatic. Like the labor of lace-makers, it practices the intricacy of handwork—a feeling craft dependent on learned patterns, a pastness present in the moment of making. Yet it also shares with the makers of digital code the practice of continually revising its processing languages, devising wholly different syntaxes adapted to contemporary conditions that incorporate past logics toward future meanings. This is the lure of the contemporary in its freedom, by which the activity of the curatorial gives itself permission to dilate. The localness of place may remain central to a curatorial project, but the curatorial remit so often seeks to disseminate and ramify—which is to say that the act of curating is always prefigured by the urge toward communicative transference, a knowledge shift from a curatorial "I" to others. The curator asks, "What does this exhibition, this installation, this artwork want from me?" just as she or he asks, "What do I want from the viewer?" and, in a way, "Who desires what I desire?" or "Who is open, willing to look at what I've looked at and think in concert with my own thinking?"

In this sense, the curatorial "I" promulgates an exhibitionary insurgency, a seeking and then declarative voice that delivers its exhibitionary effect through the enunciation of what might be called propositional refraction, the constant reorientation and distributive flow of the curator's message among viewers. But I think of this term

in relation to something slightly less sanguine that Judith Butler writes:

> If I am trying to give an account of myself, it is always *to* someone, to one whom I presume to receive my words in some way, although I do not and cannot know always in what way. In fact, the one who is positioned as the receiver may not be receiving at all, may be engaged in something that cannot under any circumstances be called "receiving," doing nothing more for me than establishing a certain site, a position, a structural place where the relation to a possible reception is articulated.[3]

In fact, it isn't that the museum, the gallery, the Kunsthalle exists so that viewers will come. It's that people always come to meeting points at the crossroads of intelligibility and exchange, and so the exhibitionary site, the museum, the Kunsthalle have come into being, and there the curator stands. Still, there's always the anxiety that the curator's articulations, this "I" toward others, isn't so much refracted as dissolved into silence and indifference. Yet if the content makes contact and the receiving is done, it's an action within a scene of reciprocity that meets the central curatorial ambition to proffer questions, learning, provocation, possibly relief, possibly excitement, a deep well of satisfaction, of gratitude—the visitor's knot of weight eased, and

3 Judith Butler, *Giving an Account of Oneself* (New York: Fordham University Press, 2005), 67.

pleasure expanding in the mind, or not eased but shifted, intensified with outrage and sadness. The curatorial site, this meeting point of meaningful delight and contestation, is all the more so today, when racial reconsiderations and social justice carry their own ethical and aesthetic energies into the museum and back out onto the street.

The "I" that is the curatorial ground of announcement and assertion extends precisely through propositional refraction, through its persuasive effort to transfer ideas via an exhibitionary sequence of visible signs (paintings, videos, drawings, photographs, objects…), inscribing in space the hovering insurgency of meanings refracted by others—imagined at once by this curatorial "I" as single subjectivities that may be actively receiving this inscription, as if written on them, or not, but also as subjectivities that aggregate, becoming signatories of the civic both in the urgency of the moment and in retrospection.

As I've said, regarding Klee's angel as a fulcrum tilted between past and future, the curatorial effect is always caught in that swift tension of the viewer's experience of a present moment nearly instantly becoming past, since that is the cognitive condition of reception. What we see and hear shift from the moment of experience to the ocean of remembrance, floating in the nimbus of only possible recollection—though hoped for, intended, depended on by the curatorial "I" if the viewer is to become that situs, that site of concentrated meaning now distributed, moving out into the dailiness of the world. The curatorial effect always locates this hope

that the pastness of the exhibition just visited isn't only past, that the curatorial work's illuminating refractions continue to enunciate its meanings, and from this a skein, a network, a woven-ness of altered understandings now lightly settles, now pervades.

In this, curatorial work is a form of portage, its narratives carrying meanings from one place to another, and each viewer is a momentary way station of reception, analysis, interpretation, judgment, doubt or refusal or acceptance—of refraction. In thinking schematically about curatorial practice in the breadth of time, we can speak of a metastatic, encyclopedic assembly, of a meta-ecstatic assembly of rearward and forward curatorial prismatic projections. Their refractions shine on a topology of exhibitionary models, formats, instances, and instantiations of particular inquiries and rhetorics, of narrative *punctums* situated in the organs of each body as witness, as organs pressed on every side by politics, bureaucracies, money, prejudices, other people's agendas. Each narrative, each portage, is an activation, an activism that inserts a piercing redirect into the locus of given conditions that it seeks to redress, the unsatisfactory revised, the scar of the unsatisfactory like a tattoo of what was on which new narratives can be imposed and might be recollected.

To stand back for a moment from what I've written—to speak of the curatorial "I," of curatorial effect, propositional refraction, and exhibitionary insurgency—is to luxuriate in Latinate abstractions and in theory. Yet to curate, to be a curator, is always, too, a form of dailiness, of labor. A difficult job, full

of negotiation and self-doubt, vulnerable and force-ful; a craft often touched by retrospective remorse about how it could have been done differently and better. Still, the curator's job is a sprawling and intricate panoply of crafts and techniques full of nuance, complicated yet frequently improved by happenstance, and finally in thrall to the possibili-ties of what accomplishment might mean, and which will be learned over and over again.

To write, then, of "thoughts on curating," as this periodic publication of single-essay volumes by leading curatorial thinkers is titled, and of which this is the inaugural volume, is to assume that history as an accumulation of enunciations and actions per-tains to a multifold curatorial "I." This many-headed creature of the exhibitionary imagination doesn't speak so much to an idea of progress as to an omni-temporal record of work, events, methods, politics, localities, stylistic explorations and obsequies, discoveries, *dérives*, inscriptions, erasures, and all neither choral nor logically cumulative, but finally is an ambience of knowledge offering forking paths useful to curatorial travel. This uneven ground, this uneven bending of the epistemological horizon, is particularly the ground of our era of the pandemic in which each body is a site of some form of repair, and what we reconstruct, and not what we recover *from* but what we recover *to*, can only be based on what we decide to propose, to map, and to make. The cura-torial per se is that anvil and hammer of research and production, that wind or low noise rising into syllables of revision, protest, justice, and praise.

Curating the Complex & The Open Strike
Terry Smith

Consider this contrast: On May 27, 2019, the Musée du Louvre was obliged to close because the attendants, custodians, and security staff found that the continuing, record-breaking number of visitors—10.2 million in 2018—had created a suffocating deterioration in visiting and working conditions, while curators feared that the crush was endangering the art on display. In response, management sought to reduce attendance and control visitor flow by emphasizing prebooked, timed tickets and renovating the most visited parts of the museum. At the same time, it strove to maintain revenue (by opening late most evenings) and the quality of exhibitions (such as a Leonardo da Vinci survey). In a January 2020 press release, the museum celebrated the success of its balancing act: visitor numbers of 9.6 million and no more staff strikes.[1]

Two months later, however, COVID-19 had been declared a pandemic and the Louvre was in lockdown, as were many other museums and exhibition spaces around the world. By June, a survey of 750 museum directors in the United States found that two-thirds predicted a severe reduction in operations, one-third anticipated the likelihood of their institution closing down in the near future, while 87 percent reported having less than twelve months in their operating reserves.[2] Visions of empty galleries and stilled spaces fading into vanishing futures were

1 See "9.6 Million Visitors to the Louvre in 2019," press release, January 3, 2020, https://presse.louvre .fr/9-6-million-visitors-to-thebr-louvre-in-2019.

not confined to the nightmares of those who work in the great institutions that collect and display art. Every artist, critic, gallerist, dealer, curator, administrator, educator, volunteer, and viewer of art is affected, whether they work or lost jobs in such places or, at the other end of the art-world ecology, they are active within an ad hoc artist's collective. Everything that distinguishes us suddenly becomes moot. Everything that connects us is abruptly rendered dangerous or at least deferrable. Everything that binds us together is now a fragile thread.

Many among us have died. Let us remember their names: Abraham Palatnik. David Driskell. Germano Celant. Helène Aylon. John Driscoll. David Leverett. Gillian Wise. Michael Sorkin. Maurice Berger. Liu Shouxiang. John Nixon.[3] If all readers were to inscribe the names of those they mourn, the rest of this book would quickly fill. My own short list includes six artists, one curator, an art critic, an art dealer, an architect, and a scholar. These are representative agents within our network. They were exemplary weavers of the art world's web. Now, those of us who remain must refrain—for a time, at least—from following our most overt

2 Nancy Kenney, "One Out of Three US Museums May Shut Down Forever, a Survey Confirms," *Art Newspaper*, July 22, 2020, https://www.theartnewspaper.com/news/one-out-of-three-us-museums-may-shut-down-forever-a-survey-confirms.

3 See, for example, "In Memoriam: Remembering Those the Art World Has Lost in the Coronavirus Pandemic," *Artnet News*, July 8, 2020, https://news.artnet.com/art-world/art-world-coronavirus-obituaries-1839576. Several magazines, including *Artforum* and *Widewalls*, have run online trackers of the impact of the virus on art-world institutions.

weaving instincts, lest we contribute, however indirectly, to spreading the virus further. Yet we must, at the same time, find ways of keeping these instincts alive, practicing them in isolation or in small, "socially distant" clusters, preparing for the time to come when—if?—the virus is quelled. But what kind of world will that be? Will the way we make art have changed in any significant way? Will the way we show it and respond to it have changed? By the time you read these words, the world around you will be supplying its answers, as will you. Beware invocations of arriving at a "new normal." They are the same old structures in falsely reassuring disguise. Our political differences will not evaporate; indeed, they may increase. But the larger world, the logic of the planetary biosphere, is insisting that future building is something we must do together, precisely by bringing those differences into concurrence.

Several questions arise, provoked as much by external forces as internal issues. They were present before the latest pandemic began to wreak its havoc. In contemporary conditions, can the established art institutions in the old centers maintain their growth without succumbing to compromised conscience and institutional palsy? At the same time, can the quasi-institutional/provisional spaces at the peripheries (including those peripheral within the centers) keep on renewing their core commitment to critical deinstitutionalization? More broadly, can the relatively open-ended "social contract" between art worlds and the societies in which they subsist survive the tempests raging within and

between crony capitalism, authoritarian statism, and fundamentalist revivalism—in other words, the geopolitical systems now fighting for their lives on a global scale? Even more profoundly, pandemics and global warming are signs that the planet's biosphere has lost patience with human self-centeredness. How must art worlds change as they join in the vast effort to find appropriate ways of being in such situations? Everything that is essential to art practice, however tortuous the journey, is predicated on acts of disclosure; everything essential to curating turns on showing, ostension, acts of exhibiting. Yet we have undergone months of self-isolation and institutional closure—in many cases, at the expense of identities, and for many venues, at the cost of permanent shutdown. At the same time, for all the outpouring of coeval communality that has occurred in societies throughout the world, we have also become aware that pandemics, insurrections, and catastrophic events will continue to roil our lives. In art worlds, how do we rethink the relationships between openness and closure in making and exhibiting art?

These are questions worth pursuing.[4] I will show in the second part of this essay that they are already leading us toward one answer among the many others that it will be necessary to find: the activist approach of "Open Strike."

4 The ideas in this essay were developed in conversation with
many people, including Steven Henry Madoff, Tara McDowell,
Rebecca Coates, Charles Green, Jelle Bouwhuis, Wouter
Davidts, Katja Kwastek, Sven Lütticken, and Steve Lyons. And
with students in curatorial studies programs at the School of
Visual Arts, New York, the universities of New South Wales,
Melbourne, and Pittsburgh, the Vrije Universiteit Amsterdam,
Ghent University, and OCAD University, Toronto. I thank
especially Steven Henry Madoff for his invitation to write
this essay and for his close editorial scrutiny, Octavian Esanu
for his help with the passages concerning the situation in
Lebanon, and Ilhan Ozan for research assistance. I thank
Niamh Dunphy and all at Sternberg Press for their input.
An earlier version of the first part appeared as "Mapping
the Contexts of Contemporary Curating: The Visual Arts
Exhibitionary Complex," *Journal of Curatorial Studies* 6,
no. 2 (2017): 170–80, with thanks to Jim Drobnick and Jennifer
Fisher. For a profile of the visual arts exhibitionary complexes
in Sydney and Melbourne, see Terry Smith, "The Australian
Art Exhibitionary Complex," in Tony Bennett et al., eds.,
The Australian Art Field: Practices, Policies, Institutions (London:
Routledge, 2021).

Cultures and economies in many parts of the world are becoming ever more dependent on the constant generation of creative attitudes and the incessant circulation of art-like images.[5] Has the art of curating art surrendered its particularity to the rampant cultural phenomenon known as "curationism"—in which every act of choice, every exercise of taste, from designing a menu to online self-fashioning (especially online self-fashioning), is "curated"?[6] No, as I will show. But there is also no doubt that these changes, among many others, are reshaping what Tony Bennett identified over forty years ago as "the exhibitionary complex"—a definitively modern public sphere that was created and sustained during the nineteenth century in Europe and the United States by art, history, and natural science museums; by recurrent public spectacles such as dioramas and panoramas, national expositions, and world's fairs; as well as by the establishment of shopping arcades and department stores, entertainment zones, and

5 See, for example, Luc Boltanski and Ève Chiapello, *The New Spirit of Capitalism* (2005; repr., London: Verso, 2018). I prefer the term "iconomy" for this system. See "After Effects— Architecture, Iconomy, Contemporaneity," the introduction to my *The Architecture of Aftermath* (Chicago: University of Chicago Press, 2006), 1–16. It has since been taken up by others, notably Peter Szendy, *The Supermarket of the Visible: Toward a General Economy of Images* (New York: Fordham University Press, 2019).

6 David Balzer, *Curationism: How Curating Took Over the Art World and Everything Else* (Toronto: Coach House Books, 2014).

publicity in its various forms.[7] The roles played by the visual arts within this complex during modern times is the subject of much research and writing, and interpretation of their contemporary purposes is growing. But wait! Something is else is happening here ... Is a *contemporary* exhibitionary complex taking shape? If so, what does it look like and what is it to curate within it?

In the main part of this essay, I will profile the institutional and quasi-institutional framework within which curators regularly work, along with other art-world agents: artists first and foremost, but also viewers, critics, gallerists, collectors, educators, and administrators, among many others. This infrastructure is made up of an enormous variety of venues, platforms, and formats ranging from the great "treasure box" museums in the

7 Tony Bennett, *The Birth of the Museum: History, Theory, Politics* (London: Routledge, 1995), particularly his chapter "The Exhibitionary Complex," first published in 1988. It is reprinted in Reesa Greenberg, Bruce W. Ferguson, and Sandy Nairne, eds., *Thinking about Exhibitions* (London: Routledge, 1996). Bennett acknowledged Michel Foucault's ideas concerning carceral regimes of truth within the modern episteme (prisons, hospitals, schools) as influential on his thinking— indeed, by emphasizing the educative role of museums and expositions, he aimed to give this picture a more positive, constructive spin. He must also have had in mind President Dwight Eisenhower's famous warning, in a television address on January 17, 1961, against the "military-industrial complex" that was, Eisenhower believed, threatening democratic government in the United States and elsewhere. See also Bennett's update, "Exhibition, Truth, Power: Reconsidering 'The Exhibitionary Complex,'" in *The documenta 14 Reader*, ed. Quinn Latimer and Adam Szymczyk (Ostfildern: Hatje Cantz, 2017), 339–52.

once-imperial cities to individual artists' websites all over the world. I will call this the visual arts exhibitionary complex (VAEC). Of course, the array varies city by city, region by region. It is in perpetual flux. Very few cities feature the entire range of possible kinds of exhibitionary venue, yet some have several variants of the same type. Each element within it has distinct characteristics and specific purposes, along with many shared ones. Most arose in response to perceived shortcomings of already existing institutions. While art worlds tend toward constant internal division, like cells that reproduce small differences, the relations within them amount to a network through which ideas, objects, and people flow. If the venues are the hardware of the complex, then the myriad relationships between them constitute its ecology.

Curating is one of the specialist practices that has evolved to enable flow around the circuitry. I will chart the protocols of curating that were forged during the modern period and those that have emerged since. These include the establishment of professional categories of curatorship, of types of exhibitions, of typical display formats, a range of curatorial styles, and the identification of certain publics. Surprisingly, there are relatively few components in each of these classifications. While invention drives art itself, regular repetition is the norm for the settings in which it is seen (think the scheduling and programming of exhibitions), although variations and combinations are frequent and seem to be increasing. Nevertheless, a widely shared sense

in contemporary art worlds is that—compared to writing art history or criticism and to buying, selling, and collecting art—curating has been the art-world profession *most* enabling of creative flow within the system. It is frequently claimed that this has been so, at least since the 1990s.[8] This claim receded when collectors came to the fore, not long before their vanities caught fire in 2008. Yet they remain ablaze, at least at the top end of the market, and are likely to continue to do so until the 0.01 percent lose their control of the levers of power. For the planet's sake, let it be soon.

The contemporary VAEC has been feeling the effects of such tensions for some decades: as a system, it seems to be fragmenting even as it expands exponentially. We have seen unprecedented growth in museum building and attendance, a surging art market, and a worldwide proliferation of biennials. Within and outside of these, conventions are defended. But fresh settings for artistic and curatorial invention are also being actively sought. At the same time, small-scale, diversifying infrastructural modes continue to emerge. So do different and diverse temporalities: occasional, temporary, incidental. Individualism retreats, cooperation becomes a norm. An example is the work of the Jakarta-based cultural collective ruangrupa. Inspired by Reformasi ideas and the energies of local youth culture, especially music and film, it established an urban center

8 For example, by Charles Green and Anthony Gardner in *Biennials, Triennials, and Documenta: The Exhibitions That Created Contemporary Art* (London: Wiley-Blackwell, 2016).

for cultural creativity in 2000 that now ranges from serving local needs, through staging regional exhibitions and participating in international ones, to curating documenta 15, scheduled for mid-2022. Meanwhile, other kinds of platforms are being tested, such as realities augmented virtually or entirely virtual, as we shall see.

Before the latest pandemic, some parts of the VAEC (the tourist museums, for example) risked combustion through the excesses enabled by untrammeled success, while others (galleries in war zones and critical art spaces in populist, fundamentalist, and authoritarian regimes) were fighting to maintain their fragile hold on public visibility. The pandemic impacted VAECs everywhere. Lockdowns and closures meant that attendance at the world's one hundred most visited museums dropped by 77 percent, from 230 million in 2019 to just over 54 million in 2020. Visits to the Louvre fell by 72 percent, to 2.7 million; at the Metropolitan Museum, by 83 percent, from around 6.5 million to just over 1.2 million.[9] Impacts were uneven, exposing inequities within VAECs, mirroring those in the wider society. Long-running institutions experienced the future anxiety that is normal for the precariat. Throughout the United States, 28 percent of museum workers were furloughed or dismissed. In New York, two thirds of creative-sector workers lost their jobs. Similar scenes are occurring in

9 Emily Sharpe and José da Silva, "Visitor Figures 2020," *The Art Newspaper*, March 30, 2021, https://www.theartnewspaper .com/analysis/visitor-figures-2020-top-100-art-museums.

VAECs throughout the world, as the pandemic piles onto existing pressures.

Facts such as these remind us that VAECs are not, in their actuality, simply physical infrastructure by analogy to, say, the material elements of a transport system. A VAEC in every city, town, or nation is also a cultural sector that is constantly created, sustained, and recreated by all those who work within it. For this reason, precisely because of its definitive contradictions, I believe that it remains our most important internal resource in these troubled times.

The Visual Arts
Exhibitionary Complex

Given that the initial purpose of visual art is to be seen, it is no surprise that exhibitionary venues are among the primary pivots, or nodes, around which art worlds are constructed. Competing conceptions of where, when, and how this seeing might take place means that these venues contribute significantly to the making of aesthetic meaning. Of course, places designed or adopted for the exhibition of art interface with other venues—such as non-art museums, sites of worship, mass communication organizations, social media, and tourist venues—which are also exhibitionary in nature. These, in turn, are shaped by other, larger formations and processes (economic, religious, and governmental ones, for example) that powerfully constitute societies. Within the cultural sector, each of the art fields has developed its own specific domain, but none match the quantity of participants (producers, consumers, and prosumers) within the visual arts. We can, therefore, speak of a VAEC: the sites of a cultural sector with its own evolving ecology, a distinguishable sector of the broader economy of most societies, with a weight and prominence that resonates through their cultures.

To picture its constituents, we might first consider this "complex" abstractly, by analogy to an industrial complex, as a clustering of places, organizations, and professionals with the fundamentally convergent goal of making art public—but with

somewhat distinct purposes and protocols in the ways they do so. We could arrange them as a list, vertically, top to bottom, thus profiling the cultural clout to which they aspire, modifying it with that which they usually achieve in actuality. Or we could, as I prefer, arrange them in a cluster, center outward from the most institutionalized to the least, from the one closest to the core of power in a city or state to the one farthest away. Alternatively, we could organize this list or chart to start with those institutions and cultural producers most committed to the idea that art changes slowly, almost imperceptibly, like language, and then move to the "cutting edges," to the locations of those dedicated to showcasing the excitement of a difference as it is born, a debate as it erupts, or a time when attention must be paid to originality as it appears in the world.

Within this complex, the universal history of the art museum takes pride of cultural place in most Western metropolitan centers, not least because it makes available to people (in democratic principle, anyone willing to enter the imposing edifice; in practice, those who see no barriers to doing so) artifacts from past civilizations as works of art, along with modern and sometimes contemporary art. Boris Groys reminds us that nearly everything on display in such places is a relic from the lives of the holy or supposedly so, the powerful in actuality or aspiration, and the merely rich.[10] We the people are invited

10 Boris Groys, *In the Flow* (London: Verso, 2016), 47–49. See also his *On the New* (1992; repr., London: Verso, 2014).

to admire the craft skills and the creativity of some among the tradespeople who served those who were once our overlords, while reliving yet again our apparently total historical victory over them. From this perspective, such museums are schools that teach us awe.[11] The question arises: For how long will the major museums—such as the Metropolitan Museum of Art, New York, the Louvre in Paris, the British Museum, London, and the State Hermitage Museum in St. Petersburg—remain the high temples of Art, the anchors of this pseudo-democratic anachronism? Actually, this question has been asked since the late eighteenth century, and at times, such as in Russia in 1917, revolutionary answers have been given. Yet a wide-scale radical answer is perpetually deferred, not least because of capitalism's record of almost unbroken success in continually expanding the numbers of those who fall within its purview. Its time, however, is up—or nearly so—as a small yet growing chorus of commentators are claiming with a plausibility that increases each day.[12]

When we set out to map this VAEC, we see that these seemingly public palaces of art are surrounded by a huge variety of venues devoted to more specialized collections of artifacts and artworks, each assembled under a more specific

11 This is the argument of Pierre Bourdieu and Alain Darbel, *The Love of Art: European Museums and Their Public* (1969; repr., London: Polity Press, 1991).
12 See, for example, Paul Mason, *Postcapitalism: A Guide to Our Future* (London: Allen Lane, 2015); and McKenzie Wark, *Capital Is Dead: Is This Something Worse?* (London: Verso, 2019).

heading. They include period museums (ancient, medieval, modern, contemporary), national collections, geopolitical area or civilization museums, city museums, university galleries, art-school galleries, private-collection museums, single-artist museums, those showing art made in one medium, and spaces dedicated to large-scale commissioned installations. All are collection based and operate as banks of concentrated cultural value. This value, known since the eighteenth century as aesthetic value, is established through a circuitry of exclusion and inclusion, of self-definition and consensual acceptance—that is, a constant process of creating and sustaining what we call "the history of art." Working with the academic disciplines of archaeology and art-historical studies, among others, museums slow down artistic time, layer it, and spatialize it—*shaping time*, in George Kubler's felicitous phrase—thus transforming art's contemporaneity into its history.[13]

Adjacent to these houses of art are various venues that do not have collections as their basis but are devoted above all to changing exhibitions: Kunsthallen, alternative spaces, parallel galleries, artist-operated initiatives, and satellite spaces. A different adjacency is afforded by local commercial art galleries, those that specialize in art from various periods or mediums and art that caters to a variety of tastes. On national and international scales, they gather in art fairs, increasingly so over

13 George Kubler, *The Shape of Time* (New Haven, CT: Yale University Press, 1962).

the last twenty years. Auction houses also service this range of interests and tastes, devoting regular sales to them during a calendar year, thus setting the annual temporal rhythm of the global art market.

Today nearly all of these venues, central or adjacent, have online sites, mostly devoted to the preparation or the follow-up to a visit to the physical plant. Some have been augmented to become quasi-exhibitionary venues in themselves. This holds true for an increasing number of sites, temporary and longer lasting, that have no physical exhibition spaces but nonetheless conduct discussions and display artworks, records of events, and texts both in situ and online.

Each of these places and this overall pattern will be familiar to anyone interested in the visual arts, particularly those who live in a city with one or more examples of each type. Yet something changes when we attempt an exhaustive list of the elements that make up this complex. Some premodern places that emphasized the exhibition of artworks persist, notably churches, aristocratic art collections, and cabinets of curiosities. Grand houses or ex-royal palaces now run as private or state museums, and many churches designate exhibitionary zones and times for viewing their icons as art. It is, however, the modern and the contemporary VAEC that is our focus here. Look at a list of its many kinds of exhibitionary venues:

> Universal history of art museums, period museums, national collections, geopolitical-area museums, city museums

> Civilizational, ethnic, or Indigenous museums and galleries

> Modern art museums, contemporary art museums

> Local government suburban galleries and regional galleries

Embassy or foreign cultural institution exhibitions

University galleries, art-school galleries, exhibition spaces in curatorial programs

Single-artist museums, portrait galleries, one-medium museums, and spaces dedicated to large-scale commissioned installations

Kunsthallen

Not-for-profit alternative spaces (also called parallel galleries in Canada)

Artists' associations and artist-operated initiatives

Satellite spaces (often temporary) of established venues

Exhibition venues of art foundations (some of which have collections)

Institutes of various kinds that include exhibitions as one part of their research, publications, and educational activities

Residency-related exhibitions

Interventions, temporary events, pop-ups

Publications designed as exhibitionary spaces

Biennials

Art fairs, commercial or dealer galleries, auction houses

Public art

Amateur art shows and art in non-art venues, including other kinds of museums (historical, science, ethnographic, children's, war, ethnic, medical, historic houses, etc.); in archives and libraries, hotels, shopping malls, real estate ventures, public parks

Recurrent public events (celebrations, festivals, carnivals) that regularly include art exhibitions or installations

Social-media and online sites, including Facebook and Instagram, Google Arts & Culture, Weibo, and WeChat, as well as Second Life and Oculus, all of which host art and art-like images

The sheer size of this list (forty-three types, here clustered in twenty-two categories) will astonish those who have not previously attempted to picture the kinds of places in which art is shown in a single city. It will not, however, surprise those who compile or regularly use art guides familiar to

gallerygoers, either as monthly printed circulars or as online listings, such as that provided by artforum.com for museum and commercial gallery showings in major cities. But its range and variety might shock even experienced people in the art world, especially when they also register the fact that, in numerous cities, large numbers of these different kinds of venues exist—for example, as of 2019, Tokyo had 575 art galleries, 260 museums, and 227 libraries.[14] Regular attendees may draw fine distinctions within each category, based on the exhibition programming offered by different venues. However similar to others of their type they may seem, each venue will have a tendency that distinguishes it somewhat from even its closest companion. This drive to differentiation within what is understood to be a shared commitment to making art public animates the entire ensemble and curating in particular.

The list may be read in a variety of more general ways, at least four of which are of contemporary relevance. First, in *historical sequence*, as indicative of key moments, definitive changes, and persistent paradigms during the modern period, followed by the diversification that prevails to the present day. While the collecting of precious items is known from the earliest civilizations and became systematic during the Hellenistic age, we can trace an overall development of modes of collecting and

14 *Monocle*, no. 125, July/August 2019, 44. Greater Tokyo does, after all, have a population of forty million, and each prefecture its own array of cultural institutions.

display. Concentrated aristocratic displays of wealth and power, both commissioned works and the fruits of colonial conquest, was followed by the use of art for bourgeois self-aggrandizement. Then came modernizing, democratic exhibitionary institutions aimed primarily at mass public education and the elevation of taste. Now, under contemporary conditions, we see the emergence of venues, formats, and events that display art's proliferation, diversity, and disjunction. Nearly all institutions and practices of the VAEC invented during modern times have persisted into the present, which places the constant burden on them of needing to change in ways that may go, often and at least in part, against their institutional grain.

An important historical caveat is required. It should first be noted that the VAEC outlined here is primarily North Atlantic in scope—that is, it presumes mixtures of private and public patronage, markets, barter, volunteer labor (by docents, for example), and what is in effect the forced free labor of interns, as its socioeconomic setting. We should not forget that similar exhibitionary formats were to be found in the other great framework for art training, art practice, and curating that was developed during the twentieth century: the professionalized, state-related, nonmarket, socialist art system in the U.S.S.R. and its spheres of influence such as Cuba. During the Cold War, this system was widely influential, especially in Africa and throughout Asia, including Vietnam, Indonesia, and for some decades in China. Although fading today, it continues to

resonate and has recently begun to arouse the interest of archivists, researchers, and artists.[15]

Second, these venues may be read as indicators of position within a volatile and shifting hierarchy of cultural power. Roughly speaking, we find at the top or center the most powerful and therefore most prestigious dispensaries of aesthetic value (and for their supporters, social cachet). We then move down or outward through those who would reform the system in accordance with the intensity of their belief in the need for transformation. At the bottom and at the peripheries, the newest challengers to the system appear. This hierarchy has never been simply based on distinctions made according to class. It has always manifested the systemic inclusions and exclusions that shape genders, sexualities, and races in the broader societies in which every VAEC is embedded.

Third, despite the obvious drags of institutionalization within every persistent social form, no element within this system remains a pure expression of its foundational purposes (most of which were double, if not multiple in character, anyway). Each has an internal dynamic that animates it. For example, all art museums are driven by the contrary pull of preserving collections *and* showing new art or new perspectives on past art. This is the dynamic of the slow yet infinitely accumulating time of the "permanent" collections on display vis-à-vis the faster changeover of the temporary exhibition

15 For example, Alison Carroll, *The Revolutionary Century: Art in Asia, 1900 to 2000* (South Yarra, VIC: Macmillan Australia, 2010).

rooms. The modern museum is driven by the pull between its desire to narrate the history of artistic modernism—or more accurately, some selected histories—through its long-term displays on the one hand, and on the other, the need to collect and show contemporary art to stay relevant. Contemporary art museums devote enormous energy to coming across as Kunsthallen or contemporary art spaces. Both modern and contemporary art museums struggle day after day with the dilemma of becoming, inevitably, historical.

Fourth, the energy of the VAEC also derives from the constant interaction between its parts. An obvious example is the phenomenon of artists acting as curators and curators acting as if they were artists. Once distinct professions, the complex exchanges between them have been definitive of much (but by no means all) innovative curatorial practice since the 1970s, exchanges that echo through a great deal of artistic and curatorial practice to this day. Another instance is the trafficking of actors across the VAEC's various levels and branches. Today, most museum curators and increasingly more directors began their careers as a member or an active supporter of an artist-run collective, an independent art space, or some other—usually several—informal nodes within the network. In contemporary circumstances, no matter where you are located within the exhibitionary complex, each element constantly strives to learn from the others, as it aspires to be more innovative and to keep on changing in order to remain alive.

In sum, we can say that the list above can be read historically, from the nineteenth century to the present. It also pictures an unstable but persistent hierarchy of cultural power, prestige, and reputation formation, exerted mostly top down or center outward. I believe, nevertheless, that the deepest dynamic within the ensemble has for decades (since the 1960s) been the creative energy and innovation that enters through the smaller and most fragile units, then spreads upward, inward, outward, and across. Overall, each type constantly learns from, imitates, and modifies the others: there is an incessant exchange of ideas, models, and personnel. Finally, while this complex has arguably reached its apogee in Western art centers—indeed, may have arrived at the point of exceeding itself—it has come to serve artists, curators, administrators, and city planners as an aspirational model of the basic infrastructure for a viable art world anywhere and everywhere. Many possibilities, but just as many problems, flow from this presumption in VAECs throughout the world today.

Curating is one of the specialist practices that
have evolved to enable the distribution of the
quintessential product of VAECs: works of art or,
some would say, visual memes. A widely shared
sense in contemporary art worlds is that—compared
to writing art history or criticism and to buying,
selling, and collecting art—curating has been the
most enabling of this flow. It seems to have occurred
in waves: a small one in the 1960s, a tsunami in
the 1990s.[16] What, then, do curators bring to
this system? What structural presumptions have
evolved to shape their practice? It is interesting
that when we attempt to chart the curating of art
as an evolving profession, we see in play the same
four perspectives—historical development, cultural
power plays, internal dynamism, and interaction
with other venues and actors—that operate within
the exhibitionary complex as a whole. Each of the
category clusters that I will now outline may be read
from these converging angles.

Art Curating: Professional Categories
As curating has grown as a practice, it has defined
more clearly the cluster of roles that constitute it
as a profession. Many of these roles have their own

16 See Green and Gardner, *Biennials, Triennials, and Documenta*;
 and Balzer, "Prologue: Who Is HUO?," *Curationism*, 7–22.

distinct professional organizations. Individuals may belong to one or more. Each organization has itself been built as an association of like-minded individuals who seek to promote their shared interests. Like all professions, it has core and marginal members, and those whom it excludes.

Museum director/curator

Museum chief curator, senior curator, associate curator, assistant curator, curatorial assistant, intern

Museum collection curator, registrar, conservator, exhibition designer

Museum curator of education, public outreach

Museum-based temporary exhibition maker

Kunsthalle, art-space director/curator

Artist-curator; curator-artist

Specialist curator (in one medium, period, approach)

Independent curator

Collector curator

Project curator

Programmer of events, festivals

Member of a curatorial collective, coproducer
of an exhibition

Curator-educator, academic curator
(art school or university based)

Curator-theorist

Research curator

Guest curator (for example, an academic,
a philosopher, a celebrity)

*Exhibitions: Historical Types, Genres,
Categories, Subjects*

Again, historical evolution, power differentials,
internal dynamics, and interaction with other venues
and actors can be seen to be in operation when we
list the actually quite limited number of kinds of
art exhibition that we typically find displayed in the
huge variety of exhibitionary venues of the VAEC.
These categories are as persistent, and as relatively
few, as may be found in any system of classification.
This is remarkable in a practice so dedicated to
innovation, surprise, and the provision of aesthetic
pleasure. But it is less than remarkable when we
recall the regularity of collection display and the
repetitions of exhibition programming that are the
staples of almost all elements of the VAEC.

Private collection displays
(domestic or grand scale)

Collection rooms in a public museum

Artist-organized exhibitions

Temporary exhibitions
(one-off, recurrent, traveling):

Surveys of: Mediums

Periods

Places (areas, nations, cities, regions)

Peoples (civilizations, Indigenous peoples, ethnicities, nationalities, folk, outsider art)

Schools of artists

Group shows (single, occasional, recurrent)

Individual artists (introductory, mid-career, retrospective, revaluation of overlooked artists)

Themes within art history

Topics, usually originating outside art

Blockbusters, mid-scale and small-scale exhibitions

Biennials

Site-specific works

Open studios

Dialogues between artists or artist/curators or artist/thinkers

Events (recurrent, occasional, one-off)

Historical Exhibition Display Formats

If curators tend to take as given a relatively limited list of exhibition types, we should not be surprised to find a similarly short list when it comes to kinds of exhibition spaces and presentation formats, that is, in the taken-for-granted character of rooms and displays even before the artworks are installed. I have in mind the curator's equivalent to an artist's *subjectile*—the ground or material on which the mark is made, the image conjured. Less surprisingly, we find a list that is also readable in the four ways I have been suggesting. The dates indicate the beginnings of each development and refer specifically to European history.

Aristocratic private collections (15th century)

Academy-based instructional displays (16th century)

Annual salons (17th century)

Civilizations, national and historical schools of art (public museums, late 18th century)

International expositions (mid-19th century)

Modern aestheticism (late 19th, early 20th centuries)

Artists' installations, manifesto exhibitions (early 20th century; 1970s; institutional critique, late 1960s)

Modernist "white cube" (early/mid-20th century)

Post-avant-garde, anti-museum exhibitions (e.g., "When Attitudes Become Form," the postwar period)

The artist's studio (1960s)

Industrial spaces repurposed (1970s)

Installations (late 20th, early 21st centuries)

Black boxes (1980s)

Open-plan, participatory, eventual (1980s)

Discursive, educational, paracuratorial (1990s)

Online, virtual (1980s and 1990s)

*Modes of Making Exhibitionary Meaning,
Curatorial Styles*

Since the 1960s, however, something has happened
to these types of exhibitions and these display
formats that obliges us to make a set of finer
distinctions so that we can capture what I believe
is distinctive about what I call "curatorial thought"
today. By this I mean the use of mental images of
artworks and projected exhibitionary spaces as
the primary materials of such thought, aided by
modelling and experimentation in the spaces them-
selves. All of the structures outlined in these lists
come into play, as do ideas about the world, as well
as one's personal experiences, hopes, and fears. Of
course, the actual pragmatics of the space and the
situation are crucial. We can, however, see a pattern
that moves from the enormously powerful influence
on curators of artists' thinking about space toward a
variety of ways of thinking about exhibitions. These
are more specifically curatorial in the sense that they
prioritize the experience of a viewer, or viewers,
imagined as moving through a set of spaces, looking
at a number of artworks that have been selected

for display in a particular sequence. I discuss the emergent distinctiveness of this kind of thinking at some length in *Thinking Contemporary Curating* and again in the introduction to *Talking Contemporary Curating*.[17] Changes in curatorial style since the 1960s can be set out schematically like this (with examples in the parentheses):

Exhibitionary modes shaped by powerful art styles:

Pop (Andy Warhol's "Raid the Icebox," 1969)

Minimalist (Donald Judd at Marfa; Dia Beacon)

Post-studio art meets the museum (Harald Szeemann's "When Attitudes Become Form," 1969)

Conceptualist documentation, archival shows (Lucy Lippard's numbers shows, 1969–74)

Interventions into non-art museums (Fred Wilson's "Mining the Museum," 1992–93)

17 Terry Smith, *Thinking Contemporary Curating* (New York: Independent Curators International, 2012); *Talking Contemporary Curating* (New York: Independent Curators International, 2015).

Postcolonial, transnational, multicultural, Indigenous (Jean-Hubert Martin's "Magiciens de la terre," 1989; Okwui Enwezor's documenta 11, 2002; "Songlines: Tracking the Seven Sisters," 2017, curated by a team of Anangu and Yanangu tribal members)

Institutional critique (Hans Haacke, Joseph Kosuth, Fred Wilson, Andrea Fraser, and since)

Gesamtkunstwerk (Szeemann's "Der Hang zum Gesamtkunstwerk," 1983), spectacle ("Sensation," 1997, organized by Norman Rosenthal), entertainment (too many examples to name; every show that ends with a gift shop)

Theatrical, dramaturgic, staging, storytelling (Jens Hoffmann, *Theater of Exhibitions*, Sternberg Press, 2015)

Subjectivist, ahistorical, transhistorical exhibition making ("Artempo: Where Time Becomes Art," curated by Mattijs Visser, Axel Vervoordt, Jean-Hubert Martin, and Giandomenico Romanelli, 2007)

Art-historical revisionism (Bojana Pejić's "After the Wall: Art and Culture in Post-Communist Europe," 1999–2000; "Global Conceptualism: Points of Origin, 1950s–1980s," 1999, directed by Jane Farver,

Luis Camnitzer, and Rachel Weiss; Connie
Butler's "WACK! Art and the Feminist
Revolution," 2007)

Programmatic, world-historical curating
(Okwui Enwezor's "Trade Routes: History and
Geography," 2nd Johannesburg Biennale, 1997;
documenta 11, 2002; "Grief and Grievance:
Art and Mourning in America," 2021)

Curating as medium (Hans Ulrich Obrist's
"do it," since 1993)

Recurating exhibition histories (Germano
Celant's "When Attitudes Become Form:
Bern 1969/Venice 2013")

Radical museology / "the new institutionalism"
(Charles Esche, Manuel Borja-Villel, Zdenka
Badovinac)

Collective, activist, creative commons
(Mary Jane Jacob's "Culture in Action,"
Chicago, 1993; "Living as Form," curated
by Nato Thompson, 2012)

Infrastructural activism (Laboratoire Agit'Art,
Raw Material Company, Center for Historical
Reenactments, Casco – Office for Art, Design
and Theory)[18]

The prior lists gathered sets of relatively neutral subcategories, while this list indicates that post-1960s modes of exhibition making were not neutral at all. They initially took the permanent collections of museums as their point of critical departure and subsequently contested museum programming of temporary exhibitions as well, thus becoming a form of ongoing institutional critique. Looking at the venues within the VAEC where these modes originated, we can see that vanishingly few of them were established museums. Most were Kunsthallen, regional galleries, alternative art spaces, or artists' collectives. Or they were biennials. It is no surprise to see the most innovative contemporary art being shown in such spaces and on such occasions. It needs underlining, however, that this is true too, and by no coincidence, of the most innovative curating.

We might also notice that recent modes of curating respond more directly to the changing social situation than to the collection practices of museums and their exhibition programming. For example, feminist critique has had some significant impacts, but as activist curator, director, editor, and academic Maura Reilly has shown, these are more apparent than real in almost every department of museums, from leadership roles through the relative numbers of women artists included in collections

18 For a more detailed outline with examples, see Terry Smith, "Artists as Curators/Curators as Artists," in *When Attitudes Become Form: Bern 1969/Venice 2013*, ed. Germano Celant (Milan: Fondazione Prada, 2013), 519–30. See also James Voorhies, *Beyond Objecthood: The Exhibition as a Critical Form since 1968* (Cambridge, MA: MIT Press, 2017).

and those accorded solo exhibitions.[19] With some notable because occasional exceptions, the same is true for recurrent mega-exhibitions, such as documentas and biennials. Slight improvements in recent years cannot yet be described as a progressive tendency. Gender disparities remain encoded in art-world structures even as they seem to be vanishing in art-world cultures. The identity wars now raging in the broader cultures of most societies are reflected here.

19 See Maura Reilly, "Taking the Measure of Sexism: Facts, Figures, and Fixes," *Art News*, May 26, 2015, https://www.artnews.com/art-news/news/taking-the-measure-of-sexism-facts-figures-and-fixes-4111. On working against this patriarchal grain, see her *Curatorial Activism: Towards an Ethics of Curating* (London: Thames & Hudson, 2018).

The vast increases in number and kind of museum visitors, and changes in their expectations, has required curators to think more precisely about just who constitutes "the public" for the art that they wish to show. I note two distinct approaches to this question, both inadequate to the challenges being posed. One, from behind the scenes in a museum, is a panoptic view that looks down through its hierarchy. The other perspective begins from below, from inside art as it is being prepared to be shown, as it searches for connection, for participants and collaborators. From both perspectives, "the public" no longer exists. Instead, an aggregation of various *publics* is usually targeted by exhibition making and venue programming.[20]

Publics (as Seen from the Center/Top of the VAEC)

Art-world professionals (artists, curators, critics, dealers, collectors, reviewers, publicists)

Art educators (teachers, historians, docents)

Students (K-12, tertiary)

20 A beginning on this necessary rethinking may be found in
 Peter Samis and Mimi Michaelson, *Creating the Visitor-Centered
 Museum* (London: Routledge, 2017).

Friends of the museum or gallery (donors, supporters, guides, volunteers)

Members (various categories, depending on degree of engagement)

Regular gallerygoers (collection visitors, special-exhibition visitors)

Occasional visitors to the gallery or participants in selected events

Cultural tourists

Online users (varying degrees of engagement)

Secondary audiences (readers of exhibition catalogues, online viewers, word of mouth, readers of a subsequent historical account)

Collaborators (as Seen from the Bottom of the Contemporary VAEC)

Coparticipants in bringing the work into visibility

Communities with whom the work is being done

Friends

Affiliates (occasional, frequent)

Other curators, artists, activists, enablers

Administrators, funders, supporters

Online users (varying degrees of engagement)

Opponents

Then all of the publics above in reverse order

Thinking about publics, audiences, participants, and collaborators remains much less evolved than the roles, presumptions, and practices of thought mapped in the other lists and charts. For example, staff and workers in a museum, gallery, or art space are, day by day, its most constant consumers, yet this fact is rarely recognized. Nor does this list readily map onto the previous ones. It is primarily managerial in character: it fits diverse complexities into measurable categories such as age, educational level, and postcode, then plans to check their current state against a near future that would show a quantitative increase in each category. Qualitative aspects are deferred as too hard to measure, although "diversity" (usually a code for addressing inherent racism, classism, gender bias, and obliviousness to disability) now leads the list of desirable mission values.

Some remarks by Vasif Kortun, a former director of SALT, the contemporary art center in

Istanbul, point us to the more subtle level on which the question of publics should be thought:

> It is essential to recognize that institutions exist in three different times concurrently. Exhibitions perform in the "present time." Meanwhile, the institution is a heritage machine bearing and asking questions around unresolved, ignored, absented, and obscured stories from the past, and also negotiating, fermenting, testing out, in the best case, possible futures. Museums' mandates used to be clear: to do everything in their capacity to advocate a better world than the one received [...].
>
> We work in a trajectory of the past and the future, which means we have multiple publics we are accountable to and need to take care of: The public of the present moment; a public that keeps arriving from an unresolved past, a past that will not go away, that has to be constantly confronted and pushed forward. Lastly, there is a future public, which is why we do what we do. So the institutional public is a plurality that does not privilege the moment, and any decision we make in the moment has an effect on all three temporalities, which includes changing the past in the present.

This is true for all elements of the VAEC, beginning with museums, whose core values, however embattled they may be today, resonate through the rest. He goes on to say:

A core issue here is to underscore the notion of a museum situated as a non-capitalist institution embedded in a turbo-capitalist economy. Please note that there is a difference between anti-capitalist and non-capitalist. The first is a political position, while the second is a public condition. It was the only condition not to be surrendered by the social state or the welfare state. Non-capitalism is about public time, which holds a society together and which turbo-capitalism has helped erode and decimate. The average lifespan of a private company is less than a century, about 75 years, but public time is supposed, or expected to be, more or less infinite. The museum is a three-century-old operation. That makes it older than most countries, economic or political systems.[21]

These thoughts challenge a view held by many curators today that their primary responsibility is to fully realize the intentions of the artist whose work they are presenting—or, more precisely, their job is to seamlessly participate with the artist in presenting the project. This approach presumes that the most relevant conception of a public, or publics, is that held by the artist, to which all others should be subject. It is a perspective that makes most sense

21 Vasif Kortun, "Questions on Institutions," *SALT.TXT*, January 12, 2018, https://blog.saltonline.org/post/169608730654 /questions-on-institutions. Originally a lecture given at the Museum of Contemporary Art Toronto, October 2017.

for contemporary art, but can also, in principle, be back-projected to shape exhibitions of earlier art. It works best, however, when the artists involved have as layered a conception of their obligations as those outlined by Kortun, himself an outstanding curator for decades. Otherwise, it is partial at best, and narrowly presentist at worst.

Curating for the artist's sake is also challenged by
the seismic shift toward valuing diverse publics
brought about by the rise of the experience
economy, within which visual imagery has become
a pervasive currency. Within this economy of
images, artworks are highly valued tokens, not
only when banked in museums but also when
generated as new images in galleries, art spaces,
and in online forums. It remains true that most
venues within VAECs take form as a physical
space in the world; a place of meeting, making,
showing, and sharing. Augmenting these, virtuality
is of increasing interest to artists, curators, and
participants as a domain for new and by now
familiar kinds of creative exchange. Increasingly,
the medium itself, whether VR or AR, is less the
attractor than is its operative potential to afford
all involved—from visitors to exhibitors—with
fresh forms of engaged storytelling, self-motivated
learning, and the pleasures of leisure. Few of those
leading this change in museums and elsewhere
throughout VAECs are formally named as curators.
Instead, they bear awkward, made-up ones such
as "Chief Experience Officer." They are well aware
that, in the words of Courtney Johnston (recently
appointed chief executive of the National Museum
of New Zealand Te Papa Tongarewa), "digital isn't
a technology, it's a way of working; digital isn't a
technology, it's a language; digital isn't special, it's

just what it is."[22] Storytelling is the overriding mode because it readily combines the personal with the communal. These innovators share this DIY attitude with the growing numbers of their generation who are populating VAECs as neither solely producers nor consumers but as prosumers readily able to mix personalized with shared experiences. Their efforts are enlivening the traditional commitments of museums, galleries, and art spaces to research, conservation, exhibition, and education by making these processes accessible to online viewing and, where appropriate, to participation. They are also enabling curatorship to expand its usual remit into direct engagement with cultural practices beyond the walls of the venue, for example, by facilitating creativity among those with little previous contact with art worlds, notably Indigenous and ethnic communities. This is best done with no expectation of a tangible return, in the form, say, of a collectible artifact. In many cases, these actions can contribute toward the decolonization of the institution.[23]

The search for ways of experiencing art in digital space exploded during the recent pandemic and now ranges across much of the VAEC. Every

22 Courtney Johnston, foreword to *The Digital Future of Museums: Conversations and Provocations*, ed. Keir Winesmith and Suse Anderson (London: Routledge, 2020), xvi.

23 Examples are given throughout the conversations conducted by Keir Winesmith in *The Digital Future of Museums: Conversations and Provocations*. Especially notable are the conversations between Seph Rodney and Robert J. Stein, LaToya Devezin and Barbara Makuati-Afitu, and Shelley Bernstein and Seb Chan.

aspect of the museum—collections, exhibitions, guided tours, school visits, artists' statements, public talks, scholarly conferences, staff meetings, and board meetings—went online in some form or another, especially onto social media. The more informal art spaces were already well embedded in network culture. Many of these changes are here to stay. The likelihood of a return to the pre-COVID degrees of separation is low. Future pandemics, social disruption, and extreme weather events will require venues to prepare for closures of physical plant, unpredictable and of uncertain length, and thus for greater reliance on virtual presence. A return to the pre-COVID overcrowding of the major venues will require the same. As does the core desire of each exhibiting agent to share their art with as many people as possible, and to do so in the most engaging and meaningful way. The tensions between openness and closure that we have been tracking throughout will find new forms.

Looking at all of the lists together, we can see that
the categories within them seem to have become
the conceptual furniture of the profession of
curating art, the main figures in its discourse, how
it pictures its "natural habitat" and inhabitants,
its ordinary language, we might say. Indeed, these
lists and charts may be giving us glimpses of what,
by analogy to language use, we might say are the
syntaxes of curating, the patterns of rule-following
and rule-breaking that enable exhibitions to work
semantically—that is to say, to enable exhibitions
to generate meanings for viewers, to create specific
kinds of knowledge.[24] This remains, however, a
loose analogy, as do other imprecise generalizations
for what is going on here. In his essay introducing
the volume of collected issues of the journal *The
Exhibitionist*, its former senior editor Julian Myers-
Szupinska test ran the idea of exhibitionary form
through the lens of the apparatus, or *dispositif*, with
mixed results.[25] The VAEC is just such an apparatus,
and its constituent elements are just what I have set

24 As representations, some of these lists and charts (the second,
 third, and fourth) might seem like syntactical tree diagrams of
 grammatical structures, used by linguists as demonstrations
 of how hierarchical syntheses operate within generative gram-
 mar. See, for example, Noam Chomsky, *Aspects of the Theory of
 Syntax* (Cambridge, MA: MIT Press, 1965); and Andrea Moro,
 Impossible Languages (Cambridge, MA: MIT Press, 2016). This
 loose analogy is subject to many of the doubts raised by most
 of the authors in "The Grammar of the Exhibition" issue of
 Manifesta Journal, no. 7 (2009/10).

out here. They are our main internal resource, as I suggested earlier and as Kortun reminds us, now that extinction is upon us and the politics of division is all-pervasive.

Something of the current sense of crisis felt within art worlds everywhere can be traced to a growing awareness that the "creative destruction" essential to the survival of shock-doctrine, "turbo," citadel capitalism is, in its recent and current forms, leading to the degradation of the elaborate VAECs in developed countries and is severely diminishing the possibility of building them in less developed countries. In the centers, this process, now two decades long, typically began with the withdrawal of funding for the most vulnerable not-for-profit organizations. Inevitably, as neoliberal economic values shrink public sectors by privatizing them, they spread to all publicly funded arts organizations. Such attrition could be the virus that contaminates the whole body because, as I have argued, it is precisely the quasi-institutional alternative spaces of all kinds, and events such as critical biennials as distinct from tourist ones, that the VAEC in particular and the economy as a whole depend on for artistic vitality and creative renewal. In many other parts of the world, however, a VAEC of the

25 Julian Myers-Szupinska, "Exhibitions as Apparatus," in *The Exhibitionist: Journal on Exhibition Making: The First Six Years*, ed. Jens Hoffmann (New York: The Exhibitionist, 2017), 16–23. A more philosophically grounded approach is taken in chapter 1 of Daniel Birnbaum and Sven-Olov Wallenstein's *Spacing Philosophy: Lyotard and the Idea of the Exhibition* (Berlin: Sternberg Press, 2019).

dimensions listed in my chart of venues (pp. 33–35) can exist only as a fantasy. A VAEC may be intensely desired for the generative benefits that its critical mass would seem to secure, but at the same time it may be despised due to its immersion in cultures and economies inimical to local values. Nevertheless, there is evidence everywhere of artists, curators, and other activists opting for the critical over the mass when it comes to building arts infrastructure, and for mass over the critical in terms of action on the streets when that infrastructure, however incomplete relative to the main centers, is threatened. One of the most recent forms of this approach is "Open Strike."

What Is an Open Strike?

On October 25, 2019, several Beirut-based arts organizations posted this call for Open Strike:

> In solidarity with and participation in the popular uprisings taking place across Lebanon against the current systems of power, we the undersigned cultural organizations and structures collectively commit to Open Strike, and call for our colleagues in the cultural sector to join us.
>
> Arts and culture are an integral part of every society, and the expanded space of creative and critical thought is imperative in times of upheaval. The strike is therefore not a withdrawal of the arts and culture from this moment, but rather a suspension of "business as usual."
>
> In this period, we will maintain minimum necessary administrative and basic operations, with team members who are willingly fulfilling our respective responsibilities. The strike is also in response to the desires of team members to be on the street, a desire we are legally and ethically bound to.
>
> While on strike, we are connecting with colleagues across sectors and groups to formulate together what we can contribute to the movement. We are part of a national, regional, and global desire to dream, think, fight for,

enact, and embody radical imaginations leading to structural and systemic change. See you on the streets.[26]

Signatories included the Arab Image Foundation, since 1997 an archive of photography in the region, especially that devoted to political purposes; Cultural Resource (Al Mawred Al Thaqafy), founded 2003, and the Arab Fund for Arts and Culture (2007–), both Open Society–kind research and support organizations; the Beirut Art Center (2009–), a nonprofit art space and publishing and discussion platform that features local and international artists; a private, collection-based former mansion, the Sursock Museum (1961–); a design museum, the House of Today (2012–); Temporary Art Platform (2014–), a curatorial collective that organizes projects, residencies, and site-specific social-practice work in public spaces; the Dar El-Nimer for Art and Culture (2016–), a private nonprofit foundation with an emphasis on art from Palestine; the Modern and Contemporary Art Museum (2013–), which occupies two converted factory spaces on a hill overlooking the city, with a permanent hall of sculpture by local artists; and the Sfeir-Semler Gallery (2005–), a commercial gallery based in both Beirut and

26 "Statement on Open Strike in the Cultural Sector in Lebanon," *Arab Image Foundation*, no. 2019.04, October 25, 2019, https://stories.arabimagefoundation.org/issue-201904. See also Hrag Vartanian, "Lebanese Art Community Joins Unprecedented Protest," *Hyperallergic*, October 25, 2019, https://hyperallergic.com/524105/lebanese-art-community -joins-unprecedented-protests.

Hamburg that shows Conceptual and Minimal art. The action was also supported by several others, including city cinemas and theaters, a war-history documentation center (UMAM Documentation and Research), a music festival, a plastic arts association (Ashkal Alwan), a comics collective (Samandal), an audio-visual company (Bidayyat), and a refugee organization (Seenaryo). Even the Beirut Art Fair, the most corporate art event in the city, was on side.

The concept of Open Strike might seem to some a contradiction in terms or a confused have-it-both-ways gesture. During the modern period, the battle between classes was usually either/or: workers withdrew their labor or bosses locked them out; battles were won or lost, but the war dragged on. Yet the struggle that is occurring today in Lebanon, and in so many other places around the world, is both/and—that is, multifaceted and differently distributed in space and time. Thus, the deconstructive logic of keeping open the places in which cultural work is done, precisely so that that work can go on, while the majority of the curators and other arts workers involved can at the same time do the political work that is also necessary by joining the protests on the streets. In this sense, Open Strike does more than keep open the art spaces, meeting places, and research centers, while enabling (most of) those who work in them to participate in the public demonstrations. It opens these spaces, already committed to art's openness, to the open-endedness of the protests themselves. It evokes the modern dialectic between the partial or legal strike versus the

revolutionary general strike, much debated throughout the twentieth century, not least by Georges Sorel and Walter Benjamin in its early decades.[27]

Yet Open Strike, as it takes varying forms in Beirut, Hong Kong, Baghdad, Paris, and elsewhere, is seeking a more contemporary form. It questions the right of the state to decide on the legality of a strike, and at the same time it opens the validity of the action beyond the working classes conceived as a proletariat toward all those who participate. After all, aspects of the desired world to come are already here: in Beirut they are embodied in the signatory organizations, which are themselves "expanded space[s] of creative and critical thought" and of "radical imaginations."[28] There are parallels to the Syrian curators and gallerists who, during the early years of Bashar al-Assad's deadly repression of his people, would continue to show art as it was being made. This was most poignantly done in the rebel-held suburbs of Damascus by projecting images on a wall for a few hours, then leaving before the bombs that would inevitably come.

27 Georges Sorel, *Reflections on Violence* (1908; repr. Cambridge: Cambridge University Press, 1999); Walter Benjamin, "Critique of Violence" (1921), in *Reflections: Essays, Aphorisms, Autobiographical Writings* (New York: Schocken Books, 1986); for discussion of the present relevance of Benjamin's essay based on a recent translation, see Walter Benjamin, *Toward the Critique of Violence: A Critical Edition*, ed. Peter Fenves and Julia Ng (Stanford, CA: Stanford University Press, 2021); and "What Is the Critique of Violence Now?," ed. Petar Bojanić, Peter Fenves, and Michelle Ty, special issue, *Critical Times: Interventions in Global Critical Theory* 2, no. 2 (August 2019), https://ctjournal.org/august-2019-22.

Improvised temporary exhibitions were a feature of various public squares during the Arab Spring (2010–12) and the color revolutions in Central Europe (1989 and ongoing), as they were in New York City's Zuccotti Park in late 2011 during the days of Occupy Wall Street (OWS). At that time, few galleries or art spaces in New York understood how they might respond. An exception was New York University's Gallatin Galleries. Its relative proximity to the park and its large street window made it a useful venue for the display on its expansive interior walls of posters, artworks, and other visual ephemera made by the occupiers. Its video monitors connected visitors to other Occupy sites across the nation. OWS also spun off an artist's collective called Occupy Museums, which, on October 20, 2011, staged protests against the influence on art of the 1 percent at the Museum of Modern Art, the Frick Collection, and the New Museum.[29] In May 2012, the collective Not An Alternative opened its Greenpoint, Brooklyn gallery, No-Space, to a production workshop for OWS videos

28 In Lebanon today, the main aim the broad social movement of which the cultural sector Open Strike is a part, is the overthrow of the system of governance via confessional sectarianism established at the end of the Civil War, in which the major religious groups divide power between them. Protest against this system thus approaches Benjamin's idea of a "pure strike," although absent perhaps of the Messianic overtones which purity had for him. Among many accounts, see Joey Ayoub, "Lebanon: A Revolution against Sectarianism," November 13, 2019, *CrimethInc.*, https://crimethinc.com/2019/11/13/lebanon-a-revolution-against-sectarianism-chronicling-the-first-month-of-the-uprising.

29 See Yates McGee, *Strike Art: Contemporary Art and the Post-Occupy Condition* (London: Verso, 2016).

and other visual images and did the same that month at Exit Art, a gallery at the time on Broadway in Manhattan.

Such actions have not gone away. In fact, they are increasing. Since 2013, New York activists, artists, and academics have been instrumental in the protests against migrant worker conditions during the building of sites for New York University and the Guggenheim Museum in Abu Dhabi.[30] Resistanbul was formed in protest against the 2009 Istanbul Biennial.[31] In Sydney in 2014, artists protested against the ill-treatment of asylum seekers in Australian detention centers on Manus and Nauru islands, Papua New Guinea, by Transfield Holdings, the main company sponsoring the Biennale of Sydney, forcing the resignation of Luca Belgiorno-Nettis, the board chairman. In New York during 2019, artists, curators, and collectives such as Decolonize This Place intervened during the Whitney Biennial to significant effect, as I will discuss in a moment. In a more traditional mode, against the resistance of its management, most workers at the New Museum, New York, formed a union. What do these events—each a version of Open Strike, each an instance of many similar ones occurring throughout the world during 2019 and

30 See Andrew Ross and the Gulf Labor Coalition ed., *The Gulf: High Culture/Hard Labor* (New York: OR Books, 2015).

31 See Angela Harutyunyan, Aras Özgün, and Eric Goodfield, "Event and Counter-Event: The Political Economy of the Istanbul Biennial and Its Excesses," *Rethinking Marxism* 23, no. 4 (2011): 478–95.

since, not least those in Cuba, led by the San Isidro Movement collective—have in common?

Some commonalities are obvious and important. One is the prominence of collective action in a sphere usually noted for its celebrations of individuality. Another is the success in achieving some if not all of the objectives, relative to decades in which such success has been rare. Less obvious is the increasing occurrence of such actions, indicating that something more significant is actually erupting: a clash of values that is, right now, roiling the societies within which these exhibitions, museums, and art spaces subsist and of which they have become such a vital part. The global failure of modern and traditional political models to manage contemporary crises, the pandemic's relentless exposure of existing social inequities (exacerbated by inequitable responses to it), the reigniting of race wars, tribal conflict, and class division—all this has directly impacted VAECs, wherever they are located. Whatever dreams of autonomy some within them may harbor are regularly relativized by such external forces. Separateness is also actively challenged by those within who have for decades fought to bring social questioning into art practice and exhibition making, as well as into viewers' experience of both.

For how much longer can this kind of contract—we might call it the "arm's-length-with-occasional-disruptions" version—between art worlds and the society within which they live remain relevant? It has rested on an understanding, usually implicit, about the balance between separateness

and sharing that underlies the concept of an art world. Now that this contract is fragmenting, how might we picture the negotiations between autonomy and obligation that shape the planes on which art making, curating, and other practices of interpreting and responding to art take place today? I have addressed this broad question in recent books, notably in *Art to Come: Histories of Contemporary Art*.[32] Here, my focus is on how the changing contract is reshaping the contexts of curating. It seems to me that open strikes are driven by desires to defend the integrity of the art of exhibiting works of art, to maintain the hard-won freedom to freely practice the art of curating art, and to do so within a society that is itself free.

32 Terry Smith, *Art to Come: Histories of Contemporary Art* (Durham, NC: Duke University Press, 2019). See also Kortun, "Questions on Institutions."

Decolonize This Place:
On the Streets, in the Spaces

As was just noted, recent events at the Whitney Museum of American Art signal the efficacy of the Open Strike model. In the summer of 2019, protests against the vice chairman of the Whitney board, Warren Kanders, owner of the company the Safariland Group, which supplies military equipment to armies and police forces around the world, eclipsed all other news about the Whitney Biennial. Images of tear gas being used by border patrol forces against would-be asylum seekers at the US-Mexico border circulated online. One hundred staff members of the Whitney signed a letter of protest against Kanders's continuing presence on the board, as did a similar number of critics, curators, and others (including me). Half of the artists in the show did the same. One, Michael Rakowitz, withdrew in protest. In the exhibition itself, one work made a direct reference to this situation. Radical filmmaker Laura Poitras, who had a powerful and moving one-person show at the Whitney in 2016, worked with the London-based group Forensic Architecture to chronicle the use of Safariland gas canisters at the border and then track their use in other situations. They also demonstrated that the bullets used by Israeli army snipers on Gaza protesters were those designed to cause maximum internal damage to their targets and that they were supplied by Safariland.[33] In his public statements, Kanders maintained that

his companies manufacture defense equipment and that he has no responsibility for the use that others make of them. Whitney director Adam Weinberg argued that the museum is a family of many parts and that one part does not interfere in the business of the others. In a letter to the Whitney staff who called for Kanders's resignation, Weinberg vigorously defended the museum's record of supporting radical art and engaging with the challenging issues of our times, claiming that the museum should be "a safe space for unsafe ideas," but "cannot right the ills of an unjust world." These defenses rang hollow to the coalition of groups that conducted a nine-week protest against Kanders in the run-up to the opening of the biennial in March 2019 and which continued thereafter. The coalition included Occupy the Museum, Decolonize This Place, Within Our Lifetime, and the Chinatown Art Brigade.[34]

After the show opened, a statement posted on *Artforum* entitled "The Tear Gas Biennial," written by Hannah Black, Ciarán Finlayson, and Tobi Haslett—writers of color with strong radical credentials—proved a tipping point. It described

33 See Forensic Architecture, interview by Zack Hatfield, *Artforum*, May 13, 2019, https://www.artforum.com /interviews/forensic-architecture-on-safariland-and-their -whitney-biennial-commission-79785.

34 See "'You Can't Hide': Protesters March from Whitney to Warren B. Kanders's Home during Biennial Opening," *Artforum*, May 18, 2019, https://www.artforum.com/news /you-can-t-hide-protesters-march-from-whitney-to-warren -b-kanders-s-home-during-biennial-opening-79854. For Weinberg's letter, see https://news.artnet.com/art-world /whitney-protest-adam-weinberg-response-1409164.

in some detail the deaths and injuries caused by Safariland products and called on artists involved to boycott the exhibition. It contrasted the growing success of wider social protests against companies such as Safariland and against the accelerating inhumanity of states toward refugees and their own citizens with the art world's relatively closeted conceptions of "radicality":

> But the art world imagines itself as a limited sphere of intellectual and aesthetic inquiry, where what matters, first and foremost, are inclusion, representation, and discussion. This ignores art's ongoing transformation into yet another arm of the culture industry, for which, as in other industries, the matters of chief importance are production and circulation. The Biennial is a major site of this activity—and thus a choke point, where the withdrawal of work has potentially powerful economic as well as symbolic effects. More than just a gesture of solidarity with victims of state repression, withdrawal of work from the gallery disrupts the actual circuits of valoriza-tion—not only of the work and its display in the prestigious museum, but of the museum and its stated interest in progressivism and socially committed art. There are moments when the disembodied, declarative politics of art are forced into an encounter with real politics, i.e. with violence.[35]

The museum's failure to adequately respond to these criticisms led several other artists to withdraw their works from the show.[36] Faced with the implosion of the exhibition, itself a signature of the museum, within a week Kanders resigned from the board, reluctantly and with rancor toward what he saw as the protesters' infringement of his right to earn cultural capital.[37] In March 2021, pressure from artists—by individuals such as Ai Weiwei and Michael Rakowitz, and through preparations for a collective strike—led to the resignation of investor Leon Black from his position of Board Chair of the Museum of Modern Art, New York, following disgust at his large payments to a convicted sex offender. Preparations for the strike were led by Strike MOMA, a coalition of collectives which issued a "Frameworks and Terms for Struggle" built around the concept of Open Strike.[38]

35 Hannah Black, Ciarán Finlayson, and Tobi Haslett, "The Tear Gas Biennial," *Artforum*, July 17, 2019, https://www.artforum.com/slant/a-statement-from-hannah-black-ciaran-finlayson-and-tobi-haslett-on-warren-kanders-and-the-2019-whitney-biennial-80328.

36 "Forensic Architecture Becomes the Eighth Exhibitor to Withdraw from Whitney Biennial," *Artforum*, July 20, 2019, https://www.artforum.com/news/forensic-architecture-becomes-eighth-exhibitor-to-withdraw-from-whitney-biennial-80366.

37 See Hannah McGivern, "Whitney Museum Vice Chairman Warren Kanders Steps Down After Months of Protests," *Art Newspaper*, July 25, 2019, https://www.theartnewspaper.com/news/warren-kanders-whitney-resigns.

38 See Robyn Pogrebin and Matthew Goldstein, "Leon Black to Step Down as MoMA Chairman," *New York Times*, March 26, 2021, https://www.nytimes.com/2021/03/26/arts/design/leon-black-moma-chairman.html. Strike MOMA, "Framework and Terms for Struggle," posted March 23, 2021, https://www.strikemoma.org.

However specific to the politics of the New York art world these events might be, a turning point has been reached. It seems, at last, that even in New York, artwashing is becoming harder to do. The internal pendulum of at least some art institutions is beginning to swing back toward the values in their mission statements: toward those in the DNA of most of the artists, curators, and audiences involved; toward a more transparent version of the institutional contract.[39] There are several signs elsewhere of such change: In London, the group Liberate Tate began protests against the funding of the museum by the oil and gas company BP, achieving success in 2017. In the largest artists' boycott in Britain to date, many participants in the London Design Museum show "From Nope to Hope," on view from March to August 2018, withdrew their works in protest against the museum's hosting of a private event for an arms manufacturer. Several of the works were shown in an exhibition in Brixton organized by the group Nope to Arms.[40] In 2019, the National Galleries of Scotland refused support from BP due to climate concerns. The British Museum, however, continues to accept such sponsorship.

39 For a subtle contextualization of "The Tear Gas Biennial" intervention, see Ben Davis, "What Warren Kanders's Defeat at the Whitney Teaches Us about How Protest Works Now," *artnet*, July 26, 2019, https://news.artnet.com/opinion /kanders-resignation-whitney-1580551. See also the statement by Decolonize This Place, "After Kanders, Decolonization Is the Way Forward," *Hyperallergic*, July 30, 2019, https://hyperallergic .com/511683/decolonize-this-place-after-kanders; and Clark Filio, "Breathing Together," *Commune*, August 6, 2019, https://communemag.com/breathing-together.

In 2019, several museums, including the Metropolitan Museum in New York and Tate Modern and the National Portrait Gallery in London, ceased accepting support from members of the Sackler family implicated in profiteering from addictive painkillers, following pressure from the activist collective P.A.I.N (Prescription Addiction Intervention Now), led by photographer Nan Goldin. Certain kinds of philanthropy are becoming toxic. The larger point is that VAECs in many places, and the international VAEC itself, are beginning to place limits on their complicity with an increasingly out-of-control capitalism and on their willingness to tolerate creeping expansions of state authoritarianism.

How to act against this toxicity? The unionization of staff at the New Museum might seem oddly anachronistic as a strategy when set against the long-term decline of union strength within the United States. But there is no inevitability to this trend, despite frequent claims that it is so. The rate of unionization has increased among public workers since 2008, although it continues to decline in the private sector. In general, however, it is plateauing, and is actually on the rise in the United States, especially among young people, as one rational response to the degradations of capital and the implosion

40 See Jasmine Weber, "Artists Protest London's Design Museum as They Retrieve Works from *Hope to Nope* Exhibition," *Hyperallergic*, August 2, 2018, https://hyperallergic .com/454036/artists-protest-design-museum-retrieve-works; and "A Statement from the Nope to Arms Collective," *Culture Unstained*, August 2, 2018, https://cultureunstained .org/a-statement-from-nope-to-arms.

of governmentality with a consequent collapse of social services.[41] At major art institutions, unions for sub-managerial workers have been commonplace since the early 1970s.[42] Yet they remain a rarity at nonprofit art spaces dedicated to showing contemporary art, many of which operate on the basis of good will, unpaid labor, and commitment to art's future possibilities.[43]

The New Museum was just such a space. It was established by Marcia Tucker in 1977 as "an exhibition, information, and documentation center for contemporary art."[44] It opened in a downtown alternative art space, moved to the gallery of the then-radical New School, then to 583 Broadway, where it was home to curators such as Lynn Gumpert, Ned Rifkin, and Brian Wallis. It gave first solo shows to a roll call of critical artists; became a center for postmodern theory (notably in the 1984 anthology *Art After Modernism: Rethinking Representation*); and was a conduit for critical art

41 See Eli Day, "The Economic Outlook for Millennials Is Bleak: Now They're Unionizing in Record Numbers," *Mother Jones*, February 9, 2018, https://www.motherjones.com /politics/2018/02/millennials-survived-the-financial -crisis-now-theyre-unionizing-in-record-numbers.

42 See Lawrence Alloway, "Museums and Unionization," *Artforum*, February 1975, 46–48.

43 The artists' collective Working Artists and the Greater Economy (W.A.G.E) has campaigned for ten years for nonprofit arts organizations to pay artists a minimum sum for the work that they do. See https://wageforwork.com /home#top.

44 See the "History" page on the website of the New Museum, accessed March 30, 2021, https://www.newmuseum.org /history.

from Latin America, especially through the work of curators Dan Cameron and Gerardo Mosquera. The museum played a major role during the AIDS crisis. Under the leadership of Lisa Phillips, after opening at 235 Bowery in 2007, it continued in this spirit by establishing the Museum as Hub initiative while at the same time embracing its opposite in exhibitions, such as "Skin Fruit" (2010), featuring the collection of one its donors, Dakis Joannou, curated by one of his artists, Jeff Koons. It was this latter ethos that resurfaced in 2019, in the instinctive resistance of the museum leadership to the unionization drive. Again, an open letter signed by several artists, curators, and educators led the museum to fire a firm that was blocking the drive and to eventually negotiate a settlement.[45] Again, a threat by artists to withdraw their work while implicitly endorsing the institution, supported by the voices of junior and some senior curators, led the director and board members of a museum to back down.

45 See "'Do the Right Thing': Artists Urge New Museum to Allow Staff to Organize," *Artforum*, January 18, 2019, https://www .artforum.com/news/do-the-right-thing-artists-urge-new -museum-to-allow-staff-to-unionize-78361; Taylor Dafoe, "A Bitter and Protracted Contract Fight at the New Museum Has Ended with a Big Win for Its Unionized Employees," *artnet*, October 2, 2019, https://news.artnet.com/art-world/new -museum-union-agreement-1667806. This victory for the staff left the curators in limbo between workers and management. In this sense, little has changed for curators since the 1970s.

Meanwhile in Beirut, an important signatory to the Open Strike call of October 2019 was the Hangar, previously an industrial space in the war-ravaged Dahiyeh suburbs and since 2004 the exhibition venue for the outcomes of research that uses the non-academic, nonstate, public archives of UMAM D&R, also located in that suburb. Typical of their work is the 2018 "essay exhibition" entitled "Lebanon 1920–2020: How Might We Commemorate This Centennial?" Collectively curated, it contests the official narrative that the nation was founded by the Treaty of Versailles, which mandated the French government to govern a defined territory of the Levant following the defeat of the Ottoman Empire in the First World War, as it did from 1920 to 1940. The exhibition invited its contributors to imagine a different kind of community, one not based on nationalistic essentialism, but on the actual history of contested national imaginaries and the civil wars, declared and undeclared, that have riven the territory ever since.[46] Curating at the Hangar, as at several of the other sites that were Open Strike signatories, exemplifies the "creative and critical thought" to which the call appealed as the basic value shared by arts workers and protesters. Both are coming together to try to imagine a future for their country

46 See "Lebanon 1920–2020: How Might We Commemorate This Centennial?" on the "Our Work" page of the website of UMAM D&R, https://www.umam-dr.org//event_detail/7/41.

other than that being caused by the compromised, corrupt, and incompetent sectarian factions whose "coalitions" regularly fail to govern.

Arts workers are also present on the streets to insist that the dense cultural infrastructure that they have inherited, and which they maintain through constant reinvention, will be an important part of that future. Beirut has a rich and varied VAEC, with inherited institutions, Western-style imports, and specifically local hybrids in the mix. Its fabled cosmopolitanism that began to appear in the arts in the 1960s was thrown into chaos during the twenty years of Civil War, then resumed during the 1990s, and has attracted considerable attention since then.[47] Several artists and theorists of international significance—Walid Raad and the Atlas Group, Akram Zaatari, Joana Hadjithomas and Khalil Joreige, Marwan Rechmaoui, Bernard Khoury, and Jalal Toufic—have emerged from this mix.[48] As well as the centers already mentioned as calling for the Open Strike, Beirut stages a regular art fair, supports several private galleries, major private collections (the Aïshti Foundation and the Dalloul Art Foundation), and small-scale initiatives such as Marfa' art space (*marfa* is "port" in Arabic and is resonant of the location of the Chinati Foundation in Texas). The American University of Beirut has

47 Charted by Sarah Rogers, "Out of History: Postwar Art in
 Beirut," *Art Journal* 66, no. 2 (2007): 8–20.
48 See especially Chad Elias, *Posthumous Images: Contemporary
 Art and Memory Politics in Post–Civil War Lebanon* (Durham, NC:
 Duke University Press, 2018).

two galleries, directed by Octavian Esanu, one housing Rose and Shaheen Saleeby's collection of modern Lebanese art, the other showing changing exhibitions (such as "Art in Labor: Skill/Deskilling/Reskilling," curated by Esanu). UMAM D&R has few parallels even in cities with long-established, replete VAECs, yet it is just one of several open-public archives that have been recently established throughout Lebanon. The explosion at the port that rocked the city on August 4, 2020, damaged several of the museums, galleries, and archives I have mentioned, due to their location in the nearby art district. The explosion also killed one gallerist and wounded others. Efforts to reopen have been hampered by COVID lockdowns and the continuing economic crisis. But most have revived, and there are some fresh initiatives with similar commitments emerging.[49] This, too, is a form of Open Strike.

49 See Rayya Badran, "In the Months After a Devastating Blast, Beirut's Art Scene Searches for New Life," *Art News*, February 4, 2021, at https://www.artnews.com/art-news/news/beirut -blast-six-month-anniversary-1234582901.

The Open Work:
Exhibitions in Preparation

The Open Strike concept is deeply resonant when it comes to thinking about how and why art is made and shown. In a fundamental sense, to make art, when it is done critically, is always an attempt to strike open, so to speak, that which is closed, to expose that which is hidden, to enliven traditions and release difference—in general, to work, openly, to make visible what the world needs to see. Curating, then, becomes the opening out (the *ex-hibiting*) of that which art has exposed and that curating itself can open out about the act of exhibiting. Both processes entail specific acts of direction, of repeating what has been done, of varying it, testing its limits. They also entail acts of indirection, of withdrawing a measure—even a large measure—of normal labor, not simply because its absence might be felt as a loss but also, and mostly, to bring a different set of relationships into existence.[50] As I said earlier, the modern social contract is fragmenting. VAECs everywhere are impacted daily by the failure worldwide of modern and traditional political models to manage contemporary crises, by the pandemic's relentless exposure of existing social inequities, and by the recurrence of race wars, tribal conflict, and class division. These

50 *What about Activism?* (Berlin: Sternberg Press, 2019), edited by Steven Henry Madoff, contains valuable suggestions by several curators for doing just this.

are pressing problems right now, but they come from long histories and will not vanish on their own accord. They require all institutions and actors in VAECs, not least curators, to work against their deleterious effects, and to combat them through an engaged criticality based on our commitments to social justice, including gender equity, freedom of expression, anti-racism, and planetary communality. The strategy of Open Strike is a practice of critical engagement. It keeps possibility alive within our workplaces, in the exhibitionary complex, and in our societies. Our contemporary situation is calling for nothing less.

Terry Smith, FAHA, CIHA, is Andrew W. Mellon Professor of Contemporary Art History and Theory in the Department of the History of Art and Architecture at the University of Pittsburgh, and Professor in the Division of Philosophy, Art, and Critical Thought at the European Graduate School. He is also Faculty at Large in the MA Curatorial Practice program of the School of Visual Arts, New York. In 2010 he was named the Australia Council Visual Arts Laureate and won the Frank Jewett Mather Award for art criticism conferred by the College Art Association (United States). In 2001–2, Smith was a Getty Scholar at the Getty Research Institute, Los Angeles. In 2007–8, he was a GlaxoSmithKline Senior Fellow at the National Humanities Research Center, Raleigh-Durham. In 2014, he was a Clark Fellow at the Clark Institute, Williamstown. From 1994 to 2001, Smith was Power Professor of Contemporary Art and Director of the Power Institute, Foundation for Art and Visual Culture, University of Sydney. In the 1970s, he was a member of the Art & Language group (New York) and a founder of Union Media Services (Sydney). He is the author of numerous books, notably *Making the Modern: Industry, Art, and Design in America* (University of Chicago Press, 1993); *Transformations in Australian Art* (Craftsman House, 2002); *The Architecture of Aftermath* (University of Chicago Press, 2006); *What Is Contemporary Art?* (University of Chicago Press, 2009); *Contemporary Art: World Currents* (Laurence King and Pearson/Prentice Hall, 2011); *Thinking Contemporary Curating* (Independent

Curators International, 2012); *Talking Contemporary Curating* (Independent Curators International, 2015); *The Contemporary Composition* (Sternberg Press, 2016); *One and Five Ideas: On Conceptual Art and Conceptualism* (Duke University Press, 2017); and *Art to Come: Histories of Contemporary Art* (Duke University Press, 2019). He is editor of many other books, including *Antinomies of Art and Culture: Modernity, Postmodernity and Contemporaneity* (with Nancy Condee and Okwui Enwezor, Duke University Press, 2008). A foundation board member of the Museum of Contemporary Art, Sydney, he is currently Board Member Emeritus of the Carnegie Museum of Art, Pittsburgh, and on the advisory board of the Biennial Foundation, New York.

Thoughts on Curating, volume 1

Terry Smith
Curating the Complex & The Open Strike

Published by Sternberg Press

Editor: Steven Henry Madoff
Managing Editor: Niamh Dunphy
Proofreading: Raphael Wolf
Design: Bardhi Haliti
Typeface: Magister (Source Type)
Printing: Printon, Tallinn

ISBN 978-3-95679-531-2

Distributed by The MIT Press, Art Data,
and Les presses du réel

MA Curatorial Practice
School of Visual Arts
132 West 21st Street
New York, NY 10011
www.macp.sva.edu

Sternberg Press
71–75 Shelton Street
London WC2H 9JQ
United Kingdom
www.sternberg-press.com